CW00863511

YR BODY/YR MIND

Your body is a temple I have desecrated
The remnants of your mind lie dissipated
This is my masterpiece, my grand manipulation
A repetition of the image of your body's desecration

If you're so holy, then I'll crucify you
And any sense of worth I had died with you
I stripped you of all your purities
A perfect shot reflection of my insecurities

THE PROVIDER

I bring you this rotted flesh
I bring you these clothes that you wear
I bring you the bitches, I bring you the whores
I bring you the night and the air

I bring you the water you drink
And I bring you the food that you eat
I bring you silence, and I bring you bliss
Yet I kneel here at your feet

I bring you the children you slaughter
I bring you the women you rape
I bring you the men whom you suffocate
And I bring you the drugs you celebrate

I bring you all the good fortune
And I bring you jesters and clowns
I bring you the tears of ten million suns
And I bring you the beer to wash it all down

I bring you this rotted flesh
I bring you these clothes that you wear
I bring you the bitches, I bring you the whores
I bring you the night and the air

I bring you the water you drink
And I bring you the food that you eat
I bring you silence, and I bring you bliss
Yet I kneel here at your feet

LIVE INSIDE ME

*We're floating in space
The stars are painting a face
Now, what feeling is this?
Do we really exist*

*In this vast open void
Where all beauty's destroyed?
An inherently cruel
Beautiful world*

*Do I feel I can trust you?
Do I even know you?
I'm just a child
You're just a vacuum*

*We're floating in space
And my body's misplaced
And we want to die
But we feel so alive*

KILLING THE CHILD

My tongue is wretched
My mind, forlorn
My eyes are scarred
My throat is torn
Your mind is mine
There's a star in your eye
A voice, it calls
From down below
Below the depths
Of all we know
Come to, breathe in
Breathe out again
We're one, we're all
Forgotten

I tried to feel
But it's so hard
Your touch, your touch
It makes me hard
Your filth, you're down
It pleasures me so
So hard to kill
The things we know
I cry, I cry
Please let me down
Please crucify me
In the ground

My mind is fucked
But not all gone
I rape, I kill
It gets me off
Your body, a scar
Your tissue is clean
You've no idea
What it means to me
I'm narcotized
I'm clear, one mind
One hand, one eye
So all can see
The things I want
You to do to me

Bury me down here
And visit sometime
I'll fuck you up
I'll eat your mind
The scars that are yours
Are also mine
One eye, one clear
Fucked up mind

I throb on pavement
For your sweet flesh
I throb on pavement
For your sweet flesh
I throb on pavement
For your sweet flesh
I throb on pavement
For your sweet flesh

Now suck us off
And leave us clean
And let us forget
Ah, make us clean
There's a star
Still in your eyes
Fueling the consciousness
Of ten thousand minds
That live in filth
And rape, and lie
Are we no better?
Why are we alive?

So, I'll hunt you down
I'll fuck you up
I'll feed you to the crows
I'll fuck you up
And keep your mind
Hidden in a jar
And keep your eye

My little star
That fuels, that fuels
That gets me high

I'll burn down ten cities
And I'll burn down ten more
Just to mangle
That fucking whore
That lives in the mirror
Resides in me
Yes, I know your beauty
Confides in me
We're sick, we're scum
We're nothing, no one
Covered in sludge
And drenched in cum
A mindless drone
To a hopeless cause
I'll murder your bloodline
Without any pause

There's a star in your eyes
There's a star in your eyes
There's a star in your eyes
There's a star in your eyes

THIS BODY IS DEAD TO ME

The pangs of your regret
Will swallow you whole
And the sun will shine down
On your naked body
Helpless in an infinite void
Dissipating to the last particle
The last part of me went so long ago
Long before I knew you

The emptiness inside you
Will claw its way out
Into your nothingness
Your volatile kingdom
Empress of dust, you are
King of all our lost dreams
Time and tide will cover you
And may God damn your soul forever

Love is a void
We are devoid
Love is a void
We are devoid

THE VOICE/THE WIND

There's a cold chill
And an empty voice
Up atop the hill
Of virtue and choice
A voice calls to me
And draws me near
And leaves me trembling
And swallows my fear
There's no sound
That can compare
To the wild banshee screams
That struck the night with terror

Staring limply
Semi-vacant
Torn through discussion
I am lost
A classical fraud
My life is a tragedy
I am begotten
We are nothing

A sound? Or a voice?
Or just simply a choice?
A vague premonition of the coming wind
Torn by love, fed by sin
Torn by love, fed by sin...

SUN/MOON

Come down here, now breathe
Touch the sun
Now, inside you
Breathe, but don't whisper

Down, down, down, down
Down, down

My soul evaporating
Touch no child of God

I'LL CRY FOR THE SUN

The seasons change
As all things must
Lying at the bottom of the ocean
Buried by eternity's dust
Come now, rise
Drown me in your misery
Feed me with lies
And wipe away the slate of history

Drowned out sounds
Calling from the back of my eyes
A vicious light
Make it so that I can see
We love the Sun
Burn away the mouth of history
Come down
Release your knowledge unto me

Behind beauty lies discontent
I can see it lurking in your eyes
A disembodied voice from a sheltered past
It calls, "leave your body, then live again"
This has to be a figment
Some false reality
You're looking crystalline, incomparable
Won't you please come and shelter me?

SHE LOVES ME

My lungs just like a desert
In awe of your splendor
Love, eternal servitude
To the father-mother mind

And now I'm talking backwards
My senses all are shot
Now I stand here trembling
But a child I am not

But I know you love the power
The feeling in your head
Filled with vagrant fantasies
Of valleys filled with death

Noise corrupts the bravest men
But a brave man I am not
I welcome it to come inside
And come and let me fucking rot

I feel it clawing at my stomach
Just yearning to escape
I will keep it deep with in
And then I'll suffocate

Because you know I love your body
Your supernatural charms
High society socialite
With a needle in her arm

I know you have yr vices
And I know you like to fuck
An open mouth between yr legs
A slow, entitled suck

I wish I was a holy man
I'd crucify the pope
And desecrate the president
And hang him with this rope

Because I know you like to test me
Just like some dirty whore
I'll snap your fingers black and blue
Then beat you to the floor

No one knows your body
And nobody ever will
The wretched sounds of your pain
They struck me rather shrill
But still
I kneel
I bleed
I break
I bleed

Since I am a wicked man
I'll leave you in the field
Then you'll know the mother mind's
Omnipotent and real

SICKNESS OF LOVE

Let me peel back the layers
The lines on your scalp
To peer into a darkness
Let me eat out your heart
The door, it won't budge
I'm trapped in this place
Between knowledge and life
With no sign of escape
Nor a sentence forgotten
A memory of bliss
Delirium setting in
A cold and lonely mist

Break our backs
We'll let you
We'll let you
We'll let you

A halo of dust
A childhood tale
All but forgotten
Every detail
I love you
I want you
And you leave me forgotten here

Emptiness, emptiness
Recoil in my brain
Take what is mine
For I am insane

ENTROPY

In my room on the 25th floor
I watched a world explode
I saw many faces and I saw a child
Who was carrying a load
I saw a father kneeling down
And slaughtering a lamb
And from inside its sacred womb
Comes the crimson river that cleansed the land

And in my bed, and in my waste
I watched a world destroyed
And in amusement, I did not hesitate
To stare there in the cold
For deep inside some crystal ball
The future is revealed
In moments of dire cowardice
A memory's revealed

And in my cavern on the 25th floor
I watched your dress fall down
Where the semen dries up cracked enough
To make your body turn around
For all we know, there's 24 floors
As we watch a world explode
Of lust and love and prejudice
Where the semen's just a toy

LUCRETIA

Lucretia;
I listen on my knees
A reflection of everything
We can be

Lucretia;
I listen on my knees
Lucretia;
I listen on my knees

I told you I would
Kill that man
If he laid
One slimy hand

I told you I would
Kill that man
I told you I would
Kill that man

Lucretia;
Like a virgin rose
You nail me to the crosses
That line the roads

Lucretia;
Like a virgin rose
Lucretia;
Like a virgin rose

I told you I would
Kill that man
Should he lay one
Grimy hand

I told you I would
Kill that man
I told you I would
Kill that man

I told you
I told you
I told you
I would kill that man

I told you
I told you
I would kill him
With no remorse

Lucretia;
My darling,
I told you
I would kill that man

LEPROSY

The sickness, it seems
Has spread to his head
Like termites to wood
It needs to be fed
It eats away
At all sense and perception
It claws at your eyes
And fucks up your complexion

And I feel alright
Yeah, I feel alright
Yeah, I feel alright
And I feel alright

The Sun is a void
It will swallow us whole
And the light will go out
And the world will explode
But I carry a crucifix
Gouged into my head
But I know there's no purpose
For I know God is dead

And I feel alright
Yeah, I feel alright
Yeah, I feel alright
And I feel alright

GERMICIDE

Throw them in the hole
Time makes this pile grow
The foul stench of hand grenades
Shrapnel burrowed into my brain

Banshee howls all around
Need a pencil to drown out the sound
The president lies like a whore
Repugnant words drip down to the floor

Germicide disfigures my hands
None of us resemble a man
Crucify the prodigal child
Leave him out in the Sun for a little while

My tongue's as vapid as fog
I'm drooling like some fucking dog
Let's burn all the books on these shelves
Though I'm mostly doing this for myself

For myself...

LEVIATHAN

Leviathan in blood
Leviathan in tears
Leviathan in shameful tears

Leviathan in secret
Leviathan in song
Leviathan in solstice
Let Leviathan live long

Leviathan in power
Leviathan in pain
Leviathan in harvest
Leviathan in rain

Leviathan in crimson river
Baptized by infant's blood
Leviathan in crimson
Leviathan in mud
Seal my words in blood
Leviathan in mud
Truth is wrought in blood

NATION

One nation under a hag
Rape them all and burn the flag
Take this rope and hang them here
Let them feel our righteous fear

Come now, one mother mind
A crucifixion standing in a line
You're just a memory of so long ago
The sacred child of a filthy whore

Come together, our might will win
Kill for what we know is true
Let the gallows stop blood like rain
For might is right and truth is pain

Come together, our might will win
Kill for what we know is true
Let the gallows stop blood like rain
For might is right and truth is pain

Come down here

One nation under a hag
Rape them all and burn the flag
Take this rope and hang them here
Let them feel our righteous fear

Come now, one mother mind
A crucifixion standing in a line
You're just a memory of so long ago
The sacred child of a filthy whore

Come together, our might will win
Kill for what we know is true
Let the gallows stop blood like rain
For might is right and truth is pain

SLAUGHTER THE MASSES

The factory's burning
I am forlorn
The factory's talking
I am stillborn
Made to remember
Each masturbation
Made to dismember
Each little nation
To slaughter their children
To look in their eyes
And grin with intent
As you end all their lives
So I drown out the numbers
I drown out the sound
Your war is a cancer
We're all in the ground

I hate you, I love you
My sweet little stars
All fifty of you
On a burning sports car
My face, it is mangled
My head on a pike

But, fuck, I love it
You know what I like
Drowned in your absence
Monetarily blissed
Momentarily misled
Deceived with your kiss

THE DEGENERATE

You know I love the way you feel
Deep inside of this mind
You know, I love the way you taste

I'm in love with your cancer
And your body is crude
When I'm inside of your stomach
That's when your cancer is food
I like the lips of my fingers
Your disease still inside
Soaking up every drop
When it is that you moisturize

And I'm kneeling inside
Deep in your cavernous brain
On your shining white light
I remain just a stain
And I know that you're bleeding
Deep between your legs
Alone
Alone

The red glow is a distance
The space between your eyes
And your chest is dry like a desert
Watered only by lies
And your face is a whore
And your mouth is a drug
And my head's on backwards
Let me go in alone

Alone I masturbate
To the sound of your ringing bells
In your eyes I can see
The distance, and I live alone
But I know you're there kneeling
In the other room
Naked on my dead body
Hard erect, like a toy
I am a little boy
I am helpless to the sound
Of repulsion and blood in your lungs
And my face, it squeezes, I breathe in
Suffocating termites
On the maggot farm beside you
Lying naked in the other room
Naked, nameless corpses
We're like necrophiles
And I want to help you feel good
And I want your body
And I want your mind, but we're okay

And I love god, and we're alright
And I love god, and I am
Mostly doing this for myself
And I watch you through the window
You look so good, I love you
Don't go, I need you
I masturbate, I feel
I need you, I feel so good
Alive, squirming in your presence
Vaginal discharge
Is so euphoric in my eyes

And I'm looking in the window
And you know you look so good
And you know I want your body
And you know I can't sleep
And you know my mind's yours
And you know I'm your maggot
And you know I'm your slave

INFANTILE

By Lucretia, I wonder
Should I be condemned?
For this body had failed me
And I'm trembling again
Because I'm lost in the mirror
And you hold the key
Both our skin burns brightly
And your love gouges me

Despite all your longing
This tumor has grown
My arms cold and flaccid
And I'm barely aglow
But there comes now a harvest
An eclipse of the moon
By the hands of your equinox
I'll be born quite anew

I don't like to be out here
Alone on this cross
When the sun beats on my chest
For hope, I am lost
Desperately clinging
To the last of your fringes
Despite all your longing
I've become quite unhinged

And by Lucretia, I wonder
Should I be condemned?
For this body had failed me
And I'm trembling again
Because I'm lost in the mirror
And I know you hold the key
Both our skin burns brightly
And your love stabs me

Your love burns in
And I won't be coming out
And I know you're dead
Beneath those bright green eyes

PARASITE

The noose of your knowledge
The drugs in your veins
The words on the wall
That drive you insane
Your pupils, erect
And we're killing again
And the sound is too strong
But I'll be your friend
And I promised my child
So that I may live again
And we washed him in blood
And we sucked on it's head
And we drank, we drank
Every last molecule
And we feel, we feel
That this world is damp and cruel

Every bruise on your body
That I fail to comprehend
Lends me validation
Infects me in my head
With a fleeting sense of power
But we're drinking again
And when the last bottle's empty
What happens to our soul?
This world is damp and ugly
Oh, mother, I am cold

Your sweet submissive child
Let me feed before the morn
And when the last bottle's empty
My parasite is born
In a vacuum filled with screaming
I swear I'll keep you warm

ARM YOURSELF WITH HATE

I don't pity the fool
Who blots out the Sun
And covers the world
Deep in his stinking cum

I move with a vengeance
Deception is swift
I am the executioner
And I rule you with an iron fist

Don't resemble morals
Don't resort to calm
It's time bear our arms
And hang that fucking bitch
Underneath the wall

A word is a moment
Just a second of bliss
Deceived by life itself
Now it's got me in the corner
And I'm covered in gallons of piss

Now maybe I'm backwards
My clothes on the floor
There's blood splattered on the wall
And I know my conscience is a whore

I'll murder your love
With my irons hands
Pull your windpipe out of your neck
And let you know that I'm a real fucking man

RISE

Rise
Above
Assume
Control
Believe
No god
Kneel
To no man
Harness
Your filth
The desire
In your bones
Reach out
And kill
Your rivals
Condemned
Leave
No lies
Let no man
Survive
Breathe
In air
Filled
With pollutants
And be
The one

To suffocate
A child
In labor
And a mother
Distilled
Bathe
In fire
And scream the name
Raise
Up hell
Up high
To the heavens
Rise
Above

HE CRIES NOT (FOR A DEAD LOVER)

Swiftly he waltzes
Through tired river streams
Infecting my consciousness
Drifting through my bloodstream
Crystalline, and still intact
Your love reflects my everything, I do
Bored with life, and it's tedious yearning
Now entwined with your delightful soul

I take my anger
I lash it out on your face
Your tears like the river
You came in on
And I deserve to drown
Oh, take me down
To the depths of your
Fiery gaze and
Let me bask in your vision
If you care to look my way
I'll only let you down

Let you down
Let you down, down, and down, and down

Swiftly, he waltzes
Through tired river streams
Infecting my consciousness
Drifting through my bloodstream

I don't love you
I love you

THE ALMOST UNBEARABLE SILENCE

Witness to my deception
Feel no pain
WItness to my false perception
Please go away
Into the setting sun
Please go away

Witness to my desecration
Fear for me
Mother of all destinations
Don't say a prayer for me
Don't say a solemn word
Don't let your spirits die
Don't pray, don't pray

Witness to all creation
Please close your eyes
Witness to dedication
Cease your little lies
No love permits my sorrow
No premonition loves
No love, no love

Witness to my broken love
I'm not coming back
I've tainted all my wisdom
And my spirits lack
Words prematurely die
Into the setting sun
I'm alone, alone

Alone.

JULIETTE'S LIPS

Juliette's lips form a vacuum in my head
Her kisses stink of roses rotting dead
And her corpses love her cemetery smile
As she drugs them with a kindness wet with bile

Juliette comes leather bound in drag
WIth the sunken, sullen fixtures of a hag
In her parties, she is sexless, blessed in blood
In a ballroom drenched in crimson crystal flood

And now
She's so unknowing of the world
Just mine
A seething, sickened patent leather girl

Juliette's holes dry, plastering in mold
Her body's good, but her kisses leave me cold
She chains me up and won't permit my leave
Juliette loves everything I don't believe

And now
She's so unknowing of the world
Just mine
A seething, sickened patent leather girl

BABYLON

In unity lies
A lonely feeling
A feeling shared
Between the likes of you and I
In this land of the free
Haven't you ever wondered
Maybe we're not all so equal?
Maybe we shouldn't all be so equal?

When you're smarter
Stronger, tougher
Less inept than those who surround you
Why should they be given the time of day?
They're given a chance to use it
And choose to sit there
And just merely exist

Each day is a testament to their insignificance
But, oh, they sure can work that 9-5
They've been given the time of day
And they've misused it
Abused it
Some suburban sad sack wants to blow his brains out
Because he's too fed up with his mediocre life?
Then let him
Let that shotgun open up what little of a mind he has
He won't be missed

You'd never even have noticed he was gone
We don't need people like this who sit around
Feeling sorry for themselves
People like us; the strong, the artistic
The intelligent
We know we are nothing except
Whatever want to be
And that no one controls our own lives but ourselves
And that nothing is stopping us from living
In our own personal paradise

We don't waste our time being mere spectators
To life's drabness
However, most people are content to do just that
Let them sit there and rot away
They're faceless peasants
Without a functioning cell in their brains

They will be buried in rotting wood caskets
Faceless bodies in nameless graves
And meanwhile;
The likes of you and I
Will prosper for eternity

Immortalized in Babylon
Immortalized in the sky
Immortalized, the Gods of man
Immortalized, Hail! The singular man

There comes a time
When the weak and the strong
Will be separated for judgment
And only the strong will survive

WHITE SHEET

TRANSPARENT, you float above my bed. Although I can't see you, I feel the weight of your body crushing down upon my chest, my bones cracking slightly with every sparse movement. I feel my rubbery skin spasm under the pressure of your gaze as a warm stream of piss travels its way into my cotton sheets; warm and wet with the vile acids of my digestive tract.

Your fingers close in around my neck, heavy and grotesque. You drive your nails deep into my skin while gently, almost seductively running your hands down my chest. With that, I start to DROOL

I start to PANT

I start to SWEAT

You drive your fingers deep inside my abdomen AS I GLEAM INTO YOUR EYES with sick admiration. Slowly, you force apart the walls of my stomach, the skin clinging on like some torn fabric on an old piece of clothing. You rip off my CLOTHING, and present me as I TRULY AM.

There is an insatiable stinging sensation as my internal organs meet the air for the first time - sharp, icy, like the feeling of your teeth when you bite DEEP into a popsicle.

Your hands now make their way to the crevices of my dry scalp, crusting with the remnants of soap uncleansed. You dig your fingers in as my head emits a slight crunching noise, and peel my face off, like removing A MASK, revealing even more of my true body.

You peel back my skin until it all HANGS in a stringy, gory mess; tattered, hanging off from the circumference of my mouth. My eyelids removed I cannot BLINK I stare continuously into your cold eyes but you are not real and your bliss is a lie you take up the sides of my bed and slowly fold them up like an enclosing tomb on an ancient god and you wrap me in my white sheet

My cocoon my rebirth and my death

THE GUN

There's a man with a gun in the line over there. Maybe he thinks nobody can see it, or maybe he just doesn't care anymore. I know I should say something, but I'm too curious to see how it plays out. He reminds me of myself; I see the strain in his eyes, and I wonder why he's doing this.

Bad day? We've all been there. Had a break up maybe? Who hasn't. Got laid off? We all know the stress, looking into your boss's eyes, struggling to resist the temptation to wrap your hands slowly around... well, we've all been there.

I'm sure the media will portray him as some sick fuck with a KINK for violence, and either pin some crackpot political movement on him or just declare him a plain old Scorsese fanatic. But I know that's not what it is.

He is every BAD DAY we've ever had, every lingering DESTRUCTIVE and SUICIDAL notion in the back of our MINDS, every BAD DATE, every SLEEPLESS night, except he's actually DOING the thing we all have IMAGINED doing at one point in our lives.

And for that, you have to respect him.

AFFIRMATIONS

I hate myself. I'm a sniveling, depressing, worthless maggot of a man. I should be beaten, and I should be raped. I should be brutalized until my weak, disgusting flesh bleeds out. The fleas should gnaw away at my scalp, tearing away the blanket that covers my INSIGNIFICANT MIND.

I deserve respect. I deserve to have the body I want. I deserve to have a good job and I deserve to have a lover by my side at night.

I'm a fat PIG, and I hate myself. When I look in the mirror I want to take a razor and slowly mutilate my GENITALS, chipping away all the imperfections, all the ill-conceived curves, the lack of endowment.

I deserve love. I deserve sex. I deserve all the money in the world. I deserve drugs and I deserve beer. I deserve to live a life of luxury.

I deserve to be lynched, dismembered; to have my fingers broken one by one and to have my fucking face smashed in. I should be gutted, my intestines ripped out and WRAPPED around my NECK and shoved down my throat.

I deserve to live a long life. I deserve to die peacefully, surrounded by my friends and my family.

I sit alone at home, NAKED, in my bed. I'm naked, but I cannot bear to look at my BODY. When I do, it brings on an overwhelming sense of repulsion. I'm disgusted with myself. My stomach sticks out too far, my dick is too small, and my thighs are lit *you are attractive* tered with stretch marks.

You are worthwhile. You you are *intelligent* worthless *and talented.*

I watch PORN and I feel ashamed of what I'm doing, still, I MASTURBATE. I jerk off my pathetic COCK and scream and I fucking *Your body is a temple* love it. I should be *held* castrated.

I like being oppressed, I like the way it feels. I know I DON'T DESERVE free will.

I can never look at beautiful people. My eyes don't deserve it.

I should love to look in the mirror, to see my smiling face, my

I should have my head BLOWN off. I wish I owned a gun

I should learn to love myself

I feel like I do not BELONG anywhere, resentment seems to follow my every turn. From people I don't know, from people I never

They appreciate you

Why can't I be allowed to get what I want? Just for fucking once I want to

I'm living my best life

I'm a FAILURE. Failure follows me everywhere. That's why I hate the Sun; it's like a shadow

I can make myself

I make myself sick

My existence is that of an *love meeting new* incon *people* venience to anyone unfortunate enough to come into contact with me. My being is inherently wrong

 Go on a diet I'm always hungry *people are starving* yet whenever I eat nothing tastes good. I'm a fat fucking *be grateful* PIG Sometimes when I'm angry I bite into my hands and they bruise and hurt for weeks AFTER *go see a doctor, your health is importan*

 Pain scares me, yet I embrace it. *I'm tough, I can take* Most things scare me, I'm a COWARD. I'm scared of losing people so I CLING ON *I never have to deal with* I threaten them, telling them that I'll KILL myself, but they've heard it all be *its not the answer, there are othe* fore I'm a greedy selfish bastard, an overattatched fucking bitch. A self-entitled *handsome* asshole *man* who *loves to* take advantage of people at every turn THAT I CAN.

 I lo *wort* ve *hwh* you, I'm craz *ile* y for *love* you *comple* completely fuck *te adoration* ing helpless for you. I'm *engaged* fucked b *my tr* ut I l *ue love* ove you *you're going* Don't take th *to be okay* is from *you're go* m *ing to be* e please *okay.*

PROPERTY

I keep her CHAINED up in the basement. The basement is decrepit, cold. The corners are textured with cobwebs and the floors are CRACKED and caked in dirt. I come downstairs throughout the day, and I BEAT HER. I brutalize her, slap her around like a stupid bitch. Sometimes it's more brutal than that, though. Sometimes I put a blade under her nails until they pop off. Then, I suck off the blood that welts beneath. Sometimes I light candles and let the hot wax drip down on her eyelids, melting onto her disgusting complexion.

It's pitch black downstairs. That way, she has no concept of time, routine, or any sense of normalcy. My home upstairs is not so ramshackle, however, it's nothing special. The kind of well-rounded American HOME that you wouldn't ever think ANYTHING BAD WILL HAPPEN in.

The basement reeks of rotted, old FLESH. SHIT and PISS cover the floor. I GRAB her by her nappy hair and drag her face through it.

I think she's finally DEAD. I can't tell. She's looked this way for weeks. Bloated, DISGUSTING.

She's fused shut, but I can break it.

A VOYEUR

My mirror greets me with sick CONTENTION.
I hate it, and I punch it; smashing the glass under the
weight of my indignant fist. My hand BLEEDS, and I
don't really care. I'm not sure of the shape of my face
these days. I subconsciously just refuse to look.
Everyone has gone now. I haven't felt warmth beside
me for months now.

And I'm alone in this hallway, vomiting at my
feet while two homeless junkies fuck in the doorway. I
can feel their eyes on me as I listen to the rhythmic
THUMPING of their bodies. I'm not puking anymore,
however my feet remain firmly planted. I feel
ashamed. I lean my head against the wall and solemnly
listen to the sounds of the junkies FUCKING; missing
the sensations that I for so long had been deprived of.

I hear his GRUNTS - so primal, so animalistic; man returning to his savage, natural state. I become erect as I paint a mental image to accompany the sounds emitting from the hallway behind me. I pull down my pants and begin to JERK MYSELF OFF. I put myself in the junkie's place; like a rabid dog forcing himself into a bitch. I CONSUMMATE my sickest obsessions. I too begin to grunt in rhythm with the male junkie. I want to peel off his skin and wrap it around my body. I want to be in his place and feel the woman's warm flesh.

I can feel their EYES on me. They think I'm sick. A sick fuck. A sexual deviant. I stand there jerking myself off with my dry hands. It doesn't even feel good. Repulsion brushed my every breath. I wanted to pull my hand back and snap my cock like some sticky, sap covered twig.

Their bodies were thumping faster now, and so were my hands. It was like there was some kind of mental link between us three. We all wanted the same thing. The junkie's grunting built up like a grand symphony of ecstasy. I was IN LOVE. I let out a vicious scream that clawed its way out of my throat AS I CAME. Now, surely, they had their eyes on me. I couldn't move. They pulled their pants back up and walked away, and I leaned my head up against the wall, trying to blend in with it. Not a word was said.

There I stood, facing the wall, a puddle of semen bubbling at my feet.

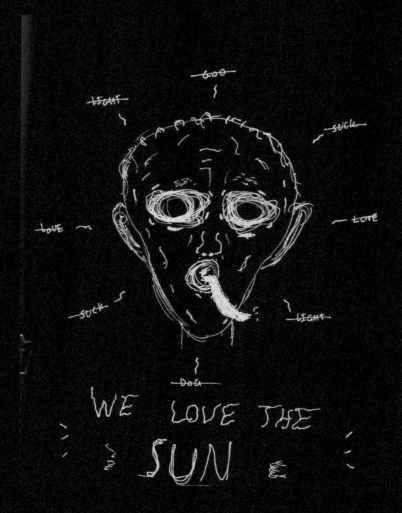

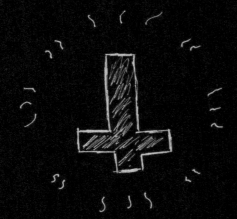

YOU FUCKING PEOPLE

MAKE ME SICK

SHE'S A UNIVERSAL
EMPATHISS

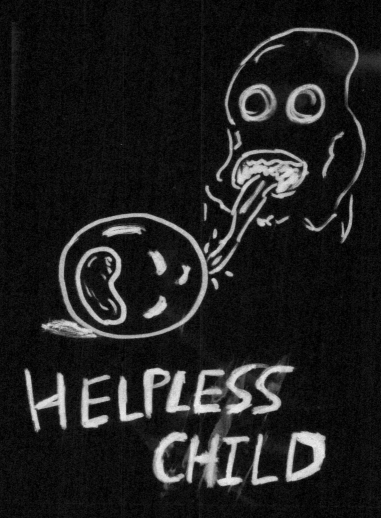

HELPLESS
CHILD

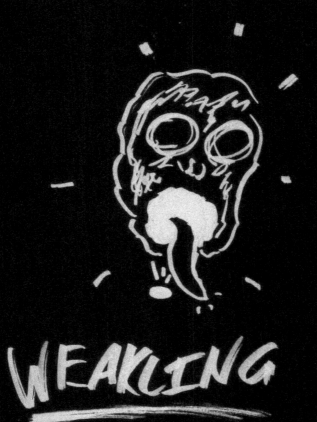

WEAKLING

This book contains writings, lyrics, and drawings from as early as late 2020, spanning to as recent as just a few weeks ago (it being 9-17-22 as I write this afterward)

Huge influences on my writing I would compel you to look into are Michael Gira, Peter Sotos, William Bennett, Boyd Rice, Anton LaVey, and the Marquis de Sade.

Please note that although my writings may be disturbing, they are not at all a reflection of my current mental state nor how I am as a person. It's all art, albeit very fringe, unsettling art.

I'd like to thank Luke and Ashley for always supporting me and giving me inspiration, as well as working with me to bring my ideas to fruition, as I always try to return the favor.

Thank you for your time reading this book if you have made it this far. It truly means the world to me, and I hope I have brought you some semblance of provocation or entertainment. As long as it has touched you or made you think in some way, that is enough for me.

I would advise you to go check out my music, you can find it on the link advertised on the front page of this book (if curiosity didn't already get the best of you).

I have desired to make a book to preserve this era of my art for some time now, and after many attempts, my vision has come to fruition with this book. I will continue to make these archives of my work for years to come, and hopefully you go out of your way to get them when they do arise.

(My cocoon / my rebirth and / my death)

DISCOGRAPHY

I Am Singing to You From Another Planet

Sadness Eludes the Common Man, But Not Us, We Are Different

Nihilist Beat Sequencer

I Am Mostly Doing This for Myself

The Ruins of a Man Forgotten